Miraculum Monstrum

Miraculum Monstrum

a hybrid narrative by

Kathline Carr

Red Hen Press | Pasadena, CA

Book design by Selena Trager
All artwork copyright © Kathline Carr
© Kathline Carr/Jim Peters collaborative photos in Fig. 1.6, 2.4, 3.4, 4.2

Library of Congress Cataloging-in-Publication Data

Names: Carr, Kathline, 1966–author.
Title: Miraculum monstrum / Kathline Carr.
Description: Pasadena : Red Hen Press, 2017.
Identifiers: LCCN 2017011712 | ISBN 9781597096072 (softcover : acid-free paper) | ISBN 9781597095983 (ebook)
Classification: LCC PS3603.A774253 M57 2017 | DDC 813/.6—dc23
LC record available at https://lccn.loc.gov/2017011712

The National Endowment for the Arts, the Los Angeles County Arts Commission, the Dwight Stuart Youth Fund, the Max Factor Family Foundation, the Pasadena Tournament of Roses Foundation, the Pasadena Arts & Culture Commission and the City of Pasadena Cultural Affairs Division, the City of Los Angeles Department of Cultural Affairs, the Audrey & Sydney Irmas Charitable Foundation, Sony Pictures Entertainment, Amazon Literary Partnership, and the Sherwood Foundation partially support Red Hen Press.

First Edition
Published by Red Hen Press
www.redhen.org

for Jim

CONTENTS

From the desk in front of my window I watch swallows fly. One little forked-tail beauty swoops in toward the window and with all its speed I fear a crash. But it swerves away at the last minute. Coming close to me, I see its pearlescent feathers. Joy!

"Joy!" exclaims the flying Tristia Vogel of Kathline Carr's *Miraculum Monstrum,* who is an artist living at the beginning of a world without oxygen. And who grows wings. And the confusion of "who" in the grammar I chose is indicative of the book's fiction, biography, autobiography. The joy of flight—in the actions of the protagonist and in this book's soaring genre abandon—is possible despite an overwhelmingly inhospitable context. I almost wrote "in hospital context," which is one of this book's truths: institutions rarely serve the ones who are meant to fly. Yet it is inevitable that some should sprout wings—if it chooses you, I think the book argues, you are called on to be susceptible.

But this special state does not mean that the one with wings does not need help. And two women in this book *do* help: an ex-junkie and a lone curator committed to presenting the exhibit and catalogue: the book of Tristia Vogel's story and works. The feminists, whether addicts or well-dressed professionals calling themselves "feminist" and "woman" or not, will always be necessary for some among us to be represented without sanitizing the story. Who are you? The curator, the friend, the artist, the monster? The junkie, the doctor, the disobedient nurse whose swollen ethics set Tristia free? Kathline Carr's book invites us to entertain both, all.

Many protagonists in literature have taken on wings: from Icarus to Anne Carson's Geryon who is a re-write of Greek mythology. And I thought of Ilya Kabakov's paintings of people in flight and also of Unica Zürn—the surrealist

who jumped from the famous male artist's balcony. But I am always ready for a new take on a tradition, and sometimes reading a book is like writing your life anew. Because lately I have been asking what it means to claim artist as identity, to claim art as one's work when the authority of profitable science appears insurmountable? When science and positivism operate in opposition to the poetics of interconnected systems, interdisciplinary living, and permeable categories? How to plot the escape from hallways where you may be expected to know how to fly but not actually permitted to do so? Where, allies? Who, co-conspirators?

This short essay is a preface to a curator's preface, a dressing room before the act of entering the vessel before the launch. To ready the reader, I want to introduce *Miraculum Monstrum* via Robert Kocik's writings on the "susceptive system" from the edited volume *Supple Science: A Robert Kocik Primer* (ON Contemporary Practice, 2014).

Considering the susceptive alongside the immune, Kocik writes:

> As distinct from a defensive, belligerent response, the susceptive is welcoming and convivial. It is a jovial response. While memory cells involved in immunization hold a lifelong, instantly lethal grudge against a pathogen, susceptive cells function like an anti-vaccination—extending a lifelong invitation and overpowering welcome to outsiders. (Kocik, 194)

So when Kathline Carr writes that as a child Tristia has "flitting, tremolo nerves—drinking the skim from the cup" (Carr, 19) and that later, after her wings have grown and the oxygen is gone, "the barbaric lip of the world spills" (87), it is Tristia who is still drinking, who is agreeing to tip the cup, whose body has not rejected the alien wings and alien air but eventually invites them in after having escaped a doctor's attempt at a "cure." Tristia: practicing, performing susceptibility.

But why write Tristia as an artist? Why this work for her? Exploring "the mechanism of the susceptive response," Kocik posits that "habitual behavior itself may trigger a susceptive response" *and* that "sensationalism is also a potential susceptive system trigger" (Kocik, 195). I think about the labor of art, of the daily playing with materials, of making habitual gestures in order to get to the surprise gesture. Art as practice in sameness and newness, as pattern and deviation, as movement toward something familiar and an object that the making subject has never before seen. Art is boredom and excitement. In either state, when the susceptive system kicks in, suggests Kocik, ". . . one becomes aware that one is no longer made of only oneself (or that there is nothing the self is made of)" (195). Maybe this is unsettling to some, but Tristia, in an extreme case and not without struggle, shows us the joy of this anti-self awareness.

I love *Miraculum Monstrum* because it is a book of "favorable infection"—a work "against imperviousness" (197). Organisms that practice susceptibility are not concerned with attempts to isolate, to treat a part of the whole as a pathogen, to clean out and get down to an idea of originary essence. Indeed—and this is my favorite line from the book—Tristia ". . . could grow afar of purity" (Carr, 42). As Tristia's wing bones begin to form and poke out, she doesn't benefit from doctors and a visit to the emergency room. The word "Sedation" is followed by these lines: "But the miraculous feathers leak out, / people come to see" (40). So we see that modern science is not equipped to handle this miracle of leakage. No wonder the book features climate disaster, for if we had banked on susceptibility and leakage all along, maybe modernity's muscle called "progress" wouldn't have gotten so pumped up, so lethally over-developed. In another counter-modern move, the susceptible shirks off the idea of one's "marrow" which is a "specific physical location," a locatable matter that can be excised or extracted, according to Kocik's discussion of "marrow" versus "mettle." Mettle, "a physiological draw upon all of one's being, including and crossing into the

behavioral and psychosomatic . . ." is the stuff of the susceptible (Kocik, 201). And of *Miraculum Monstrum*:

Tristia's mettle as self extending beyond a body. The book extending into poem, historical document, exhibit catalogue including reproductions of paintings, prints, drawings. Tristia, eventually flying into a breakdown of language, in a space of no oxygen, yet nesting there. *Miraculum Monstrum*: a joyous rewrite of the life of one who reads, susceptibly—

—Jill Magi

Miraculum Monstrum

The events that surround Tristia Vogel's life tend to overshadow the art she made. Her name still suggests a kind of sensationalism that recalls the exploitive circumstances she overcame and evokes a mixed emotional response: admiration, pity, fear, and inevitably, worship. Still, her place as a visual artist has yet to be truly considered. What I have been drawn to most as an art historian is the way she continued to create, mutating her process to the materials at hand or the facts of her physical form. The body of work scattered along the routes where she passed is a testament to the persistence of creative impulse.

The work presented in the exhibit *Miraculum Monstrum* has been gathered or recreated from a range of sources. Tristia's visual work on display is ordered chronologically, and includes artifacts or replications from the cave at Montrozier in the Pyrenees; other artifacts or photographs are noted as such within the catalog. The notes within the text are my additions. There are sections where I felt it necessary to elaborate on some of the factual data nested into Tristia's dirge, compiled after her death and entitled ironically *Miraculum Monstrum* after the Raptus codex. It is in the spirit of the poetic text that I also entitle the exhibit *Miraculum Monstrum*.

—Carla Kase, Curator
　　Museum of Latter Hybrids (Post–Climate Disaster Collection)

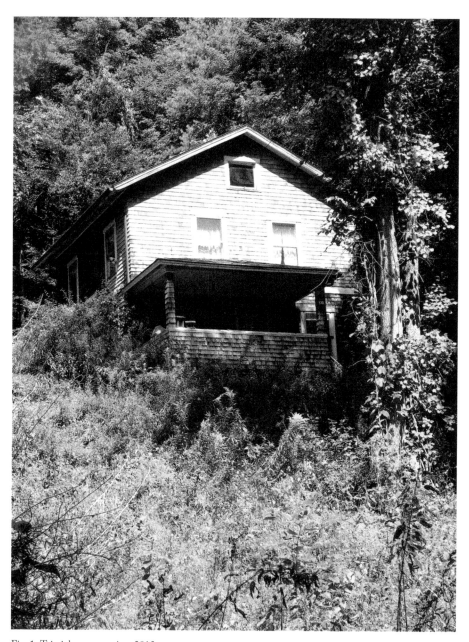

Fig. 1. Tristia's cottage, circa 2013.

miraculum: n. (I) *a wonderful thing, prodigy, miracle*

monstrum: n. (I) *a significant supernatural event, a wonder, portent/alt., a monster*

> *Nature does not know extinction; all it knows is transformation. Everything science has taught me, and continues to teach me, strengthens my belief in the continuity of our spiritual existence after death.*
>
> —Wernher von Braun

Tristia, Miraculum monstrum, rose from the sea in a fiery tower. The winged woman took the eyes from the accursed priests with her long beak, flung them into the sea. Many men starved on the shore. *Aclae*, she cried, and the broken women rose from their graves in full body. The broken women will grow wings, and all their suffering will exalt them; this is the promise of Tristia.

—Letter of Karena to the Apostates, from *Miraculum/Monstrum.*[1]

Fig. 2. Work in progress, Tristia's studio wall, 2013. Oil, Conté, wire, thread, pins on cardboard, 72 in. x 30 in.

1. *Miraculum/Monstrum* is the main text of the Raptus Cult. Only one copy remains.

I

Exornatio

Words are artifacts, relics, symbols. In spring, a rabbit
opened by a crow. Dark-edged fear writes the rabbit death.

It happens in the spring. Lilac-scented air in the park
turns pages of her book as she eats her lunch, little wings in bright sun.

An April afternoon lies on the grass, not hearing
the murder of crows' shrill gape.
The leaves knife-sharp against the sable trunks,
high-pressure finite lines written across a landscape.
She hears a bird serenade, tiny hammers on bells,
air borne notes punctuating vestiges of clouds,
now thinned to gray scraps. Her back itches.

Tristia,
a woman with brown eyes (insatiate wells)
mouth, a red moon
Manet's Morisot.
Small-breasted, muscular
yet birdlike in body—
 slender, long-waisted—
birdlike in nature,
flitting, tremolo nerves—drinking the skim from the cup.

Her mother, probing newformed eye-flesh in her womb
sees exile, *vacuus*, wandering loss felled-limb empty

a black fissure in ice
from the dead tongue poem of sorrows Ovid writes of the edge of the Rhine
(the barbaric lip of the world)
named her *Tristia*.
A cold pool, distant cries.

In her studio she paints
oval shapes. The nature of flight,
representational arcs.

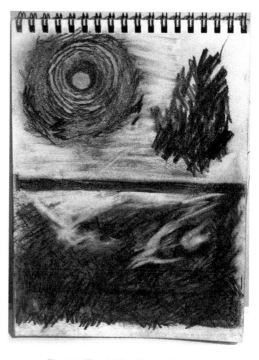

Fig. 1.1. Tristia Vogel's sketchbook, circa 2012.

(Curator) This all happened before I was born.

I imagine her as she might have been, before her transformation, before the annals of *Miraculum/Monstrum*: the lost years when she was presumably living as any human woman would. There was breathable air then. This was before the atmospheric catastrophe, before the birds died, before the winds and earthquakes—when there was waste, and leisure, whole days of temperate radiation. In retrospect her mutation was prophesied, as many things are reckoned in hindsight; her temples hewn and texts produced. Contrary to natural law, she was born out of herself in the April month, already fused to a mythology that had yet to be created. Anomaly. The persistence of peripheral vision. I imagine her in time, in the weave of every moment, regardless of fact, or record.[2]

2. Notes on an exhibition, compiled from records, interviews, and various documents. Tristia's journals provided by descendants of Percy Vogel.

Opening windows,
applying resinous winter
paint to new canvas;
shaking rugs into pale grass,
digging in the earth with fingers.
Eating plums

juice on chin, throat, between breasts—
like sweat rising from skin to cool tense muscles
clenched in anticipation of climax—sucking

plums, nectarines, the hummingbirds
hovering their soft bodies
at the wisteria, prodding

flowers with their protruding beaks.
Her skin wakes, a panting anemone.
She brings him home and they flit, hover, release,
pour sweat into strange cups.

(Her desire looks like a house. Boarded-up, empty rooms, bills in baskets
for services rendered, dusty baseboards, stacked dishes, rusty metal, blood
in floorboards, creaky bedsprings, soiled carpet, no carpet, wood flooring,
Formica counters, cigarette burn, attached garage, welcome mats, and this she
dreams into him.
Her, her latest lover, guileless as flocking
feather-spoken, she coaxed him
shyly stayed the night, one time.
There is something in the air.
Her dreams are pocked with dark places, falling from heights, oppressive heat.
There is a weight on her chest; she wakes up freezing and reaching for the
phone in the blue light of breaking morning, but whom to call.
Not *him*, he is sleeping, alone, and there is no way to rush past all the barriers
to closeness that time and loneliness construct. She sighs.)

In daylight, panic skin sloughs.

On days she paints she forms images cusping,

dream to waking images, the point of insertion. Wing tips,

bracken, nest. Flail.

Her rooms full of paintings, red globes, beaks, shades of cinder, wheat stalks.

She can't show them. Crowds fill her, their noisy blistering thoughts.[3]

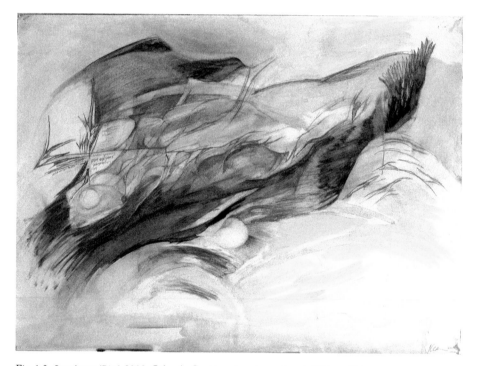

Fig. 1.2. *Landscape/Bird*, 2008. Oil, ink, Conté, watercolor on board, 35 in. x 55 in.

3. Efforts have been made to present in this exhibit some of Tristia Vogel's actual work, when it could be located, from the time prior to her metamorphosis; some has been reconstructed by curatorial staff from her journals or sketchbooks.

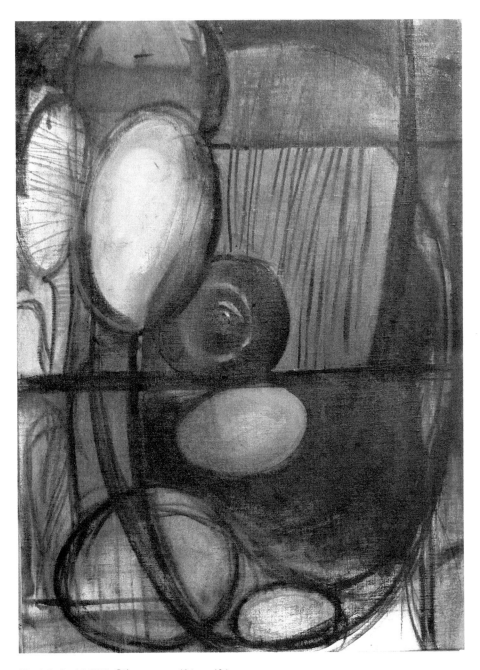

Fig. 1.3. *Ovoid*, 2010. Oil on canvas, 60 in. x 40 in.

Professor Michael Klein, Head of Foundations Department, Parsons
School of Design

Tristia Vogel is a quiet student with good aptitude for tonal
drawings and imaginative paintings that incorporate architecture
with organic form; participates in critiques minimally; has
neat work habits. Her midterm project documenting images from
eighteenth-century literature was excellent. No attendance after
midterm evaluation.

STUDENT DROP, SEMESTER INCOMPLETE

On April 25
she wakes up with a single hair
thick as a bristle growing out of her left scapula.
With a hand mirror, she examines over her shoulder.
The sinister portentous vine
looks like a wire.
She can't pull it out. It seems to be fused to the bone
under the skin it erupts from.
Is a dream the real world? This hair,
a blackened bone being born.

Beneath her skin, she feels herself leaning
towards flight patterns of bird cloud lifting off
a tree to the east of where she sits.
She isn't aware of

implications—
this small irritation on the west side of her back.

A black hair. Walking home from the park, her senses heightened,
she feels like running. Breathing hard though walking,
walking at a tilt, vertiginous sidewalks in motion
the sensation on her back
several more wiry black hairs and bony protrusions on shoulder blade.
Makes an appointment to see her doctor.

Sarcoma, could be
Ewing Sarcoma, blood sample, white paper
pale cheek to vinyl stretcher
nude from waist up, *on your stomach please*
abnormalities in chromosomes
Ewing is notably found in the bone shaft. Rare.

> *Everything, herself included, was intolerable to her. She wished she could fly away like a*
> *bird and grow young again somewhere far out in the stainless purity of space.*
> —Gustave Flaubert, *Madame Bovary*[4]

4. Underlined passage among Tristia's books. *Madame Bovary* was heavily annotated in her hand, one of
several dated at time of testing and diagnoses.

Inside her chest, the ribs rest over
peritoneal sac, housing heart, lungs.
Once she saw a bird heart still beating
in a ribboned carcass: the bird had been struck
(turned in ragged cartwheels)
glanced off a car. The body curled
like a continuous apple peel.

She walked from her porch where she had been sitting
to look at the moist shards of gelatinous red
wanted to put her finger in the chest
to touch the velvety blood charged with ebbing life
thrashing pulse, flailing wing

she can't be dying

on your stomach please

Is there pain?
Yes.

Is it a sharp pain or a dull ache?

It is pulsing, throbbing, sometimes like a knife.

There is a growth; we will order a biopsy.

Is it cancer?

It is too early to say, but possible. We will order tests,

lots of treatment options, you are

young at thirty-four,

healthy.

Is there a history of cancer in your family?

No.

Your parents, are they living?

They died. In a car accident.

Your grandparents?

My parents were both adopted.

That's unusual.

Is it? (No answer).

A medical history would be (have been) helpful.

Unspoken history: the past, tense.

Biopsy. Genetic test for chromosomal abnormalities.

Vivus sectio = *alive cutting*

migration and song "phenomena" to be dissected

article in waiting room

X-ray shows—
there is a consistency with—
perhaps fibrous dysplasia;
origins are mysterious.

Monostatic—in one bone, left scapula.
Spinal bone cysts, seem unrelated:
inconsistent with—fibrous dysplasia.
The x-ray shows pitting in the bone.
Tumor-like growths consistent with dysplasia.

Medullary bone becomes fibrous tissue.
There are growths, non-consistent.
Benign, let's hope.
The x-ray, the beating heart, caged:
this part looks like a feather shaft. We're not sure.
What this means.
Your temperature is running below normal.
Is that part of dysplasia?
No, unrelated. Do you feel cold?
No.

Alarmed, she calls him. He is sympathetic, *do you need me to . . .?*
She can hear him
holding the exhale, shaping his breath into
I can't help you
She hears him thinking, a hum she becomes aware of.
Puts the telephone in the cradle, relieved of a weight,
the machine in her hand. Death is not a sentence, only one word.
She runs at the wall, in panic.

On this night, she dreams of a dead pond: frogs belly up,
but the storks aren't feeding.
It rains an oily spatter, Starling wing speckled
the black runs down her glass porch door.
She looks closer, bird after bird
pounding soft bodies into the glass. Stunned,
they recover vertical poise and launch
into the door, again, again.

This is how she remembers the last time she saw her parents: the trip to visit her aunt, taking backroads from the city, on the way home, stopping for sodas, her mother in blue, the blue dress, yellow flowers. Piling in the car, drawing in her notebook, dozing. September sun heating the car, then the car, something violent, sightless thrashing, lying on the dirt through the open window; remember (or dream) being lifted out of the car by someone,

metal clang shudder—engine revving, cartwheel, ragged glass spraying,
branches snapping, soda spilling, tilt-a-whirl, can't remember
quiet. hissing. Head hurts. Ticking. The blood horror, mother's broken
One wheel in air, still going
Can't. Dead. mother, father, stretchers, covered, smoke, crowded
roadside, embankment, waterfall, riverbed, asleep, father
engulfed, sirens, flame, cameras, shouting, *how did you, how did you*
big as a lion, pulled her, no, she can't remember.

some thing.

A pile grows. She thinks she will vomit.
Her mouth opens (she almost breaks from the dream here)
feels/sees a bird beak writhing in her throat,
rising from her throat hole
pushing along the esophageal passage
trying to be born. Trying to escape. Trying to herald.
Arrheh! Arrheh! it is shrieking—then begins to wail, an infant.
In the dream, her bile rises, propels the bird out,
leaving her flaccid, the bones of her crushed, liquefied, or
molten.
She wakes, vomiting.
Shoulder throbbing. Sarcoma.
The moon lights translucent snakes in her vomit,
like tapeworms. Maybe string, or hair.
She takes the bus to the emergency room.
It is 2 a.m.

Fig. 1.4. *Peel*, detail, 2011. Oil on canvas, fabric collage, 30 in. x 22 in.

Medical Form, I can't read this Control #, District, am I dying worker, Phone you are upset, please calm Number, Date, client ID, The information provided temperature dropping on this form may be used to determine eligibility pressure on chest, for federal and we want you to speak to state programs using dead birds, Social Security disability criteria, 1. Patient Information, how long have you been, I am not address, Phone, date of birth, Physician's there is a research lab name, address, phone, specialty, Dates of exam, first visit, last will not live in a cage visit, presenting symptoms, Height, weight, BP, Muscle strength (1/5 to 5/5), 2. Diagnosis, you must attach, HIV infection? Diagnostic made comfortable tests performed, attach they look like feathers, can you explain results, psychiatric evaluation, psychological evaluations, Treatment and response, tests inconclusive, include past treatment we need more tests and response, be advised, this is blurry, please sign here.

We want to help[5]

5. Hospital employees stole intact and shredded records from Tristia's case file after her disappearance. They were curiosa and were extremely in demand. There were forgeries as well. Many documents remain missing.

(Hirundo rustica)
swallow, swallow bloody bird
turns milk to blood flying under the herd
flying over the house your death he portends
if he lands on your shoulder, your life will end

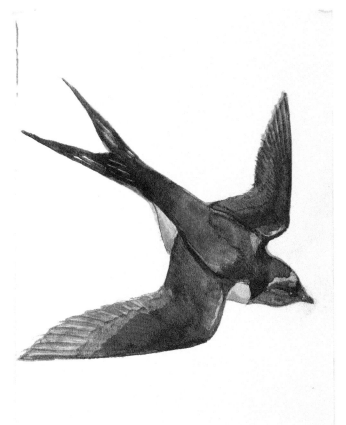

Fig. 1.5. *Swallow*, March 2013. Watercolor on board, 14 in. x 11 in.

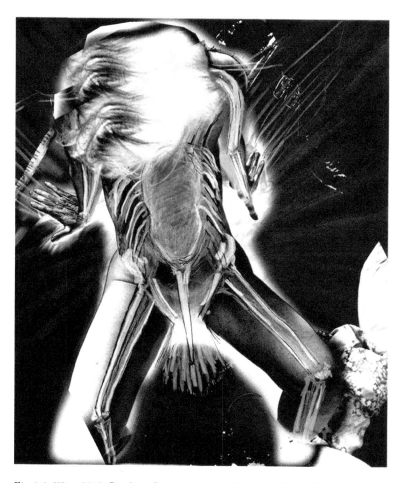

Fig. 1.6. *XRay*, 2012. Graphite, Conté on photographic print, 26 in. x 20 in.

II

Auguratio

Why did he let me go? / did he hear the whirr of wings, // did he feel the invisible host / surrounding and helping me? / was he afraid of the dead?

—Hilda Doolittle, *Helen in Egypt*

As Tristia and the broken women walked the path to the walled city, the christians followed and one of them shouted behind, "These women are the slaves of contrivances! See the monster they follow, and the demon seed still swimming in its eyes!" Tristia told her apostate Terra that this annoying harassment should stop, so they turned to the faithful and spat oil onto their skin. They ran away in fear, but continued to throw rocks from a distance. When they reached the city, Tristia spoke through Terra: "The wall they've constructed won't keep the water out, so find higher ground." The water will wash the cities away; in the caves we will breed new life. This is the Word.

—Letter from Terra, from *Miraculum/Monstrum*, 8:21.

Spanish proverb: Raise crows and they will pluck your eyes out.

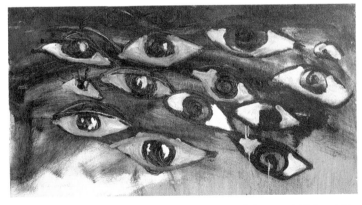

Fig. 2.1. *Eyes*, 2012. Oil on wood, 30 in. x 46 in.

They superimpose the stature of a god over her.

Morphine drip. Gurney. The beige walls, streaked with death stench.

Bony eruptions metastasize, shifting tectonic plates. Margins. Testing brushstrokes, line, tone, linseed. Testing her blood, plastic, planet, her saliva, marrow, feathers, secretions, probing her body lungs vines liver pancreas, with instruments, dermis, marrow, plasma, vial, basin, cramps, vomiting, fever, biopsy, shoulder, strata, ultrasound, x-ray, magnetic resonance imagery, dissecting specialists surgeons. Photographs documents, burning, leaking, discharge.

Sedation.

But the miraculous feathers leak out,
people come to see.

Tests mutate to experiment, papers are published.
The published papers metastasize a kind of greed
a tracking device under left wing.

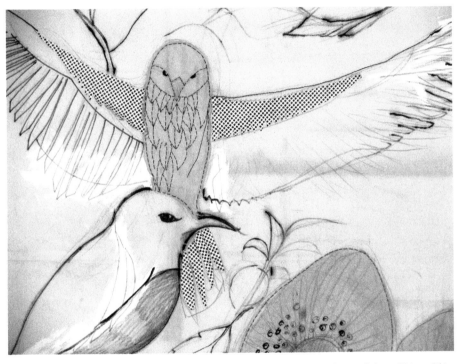

Fig. 2.2. *Span,* detail, 2013. Acrylic and stitching on hospital sheet, 72 in. x 35 in.

Disruptive, they move her
to a locked room, with one small window

make her comfortable.

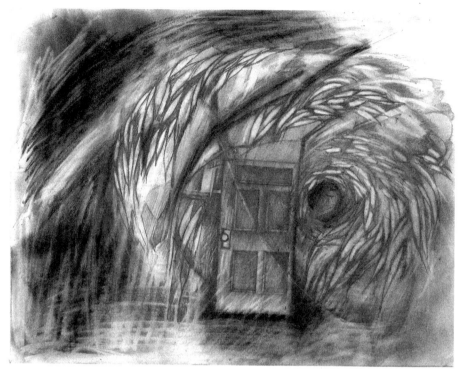

Fig. 2.3. Sketch from Brookside Hospital, 2013. Pencil on paper, 12 in. x 15 in.

Her intolerable bird

she was stainless in herself

wished everything away like space

she could grow afar of purity

fly out again young

and included

to somewhere

Cage.

Tristia sleeps. She dreams, sees the same woman over, over. A woman,

hurting herself

with a shoelace tied just over the bend in her arm.

With a needle, the dreamed woman injects herself with poisonous snakes. The snakes eat
her insides, eat her eggs, her mucus, her blood. Her child, not yet born, still in the ovary,
close to digested.

Rats, feral, sharp-toothed pulling the stops out of her brain. Tristia sees a demon, like a rat,
gnawing the lining of her medulla oblongata, heart stem

she twists into her sheets.

Tristia sees she must. *Go to her*

She opens her eyes in the dark, feels

.

in pericula vectus (she will fly)

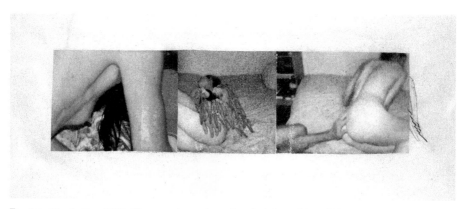

Fig. 2.4. *Alive/cutting*, 2013. Photograph transfer on hospital sheet, 7 in. x 20 in.

leather straps against her arms uncoiled feathers

sprung from the bone meat, this feather of undaunted blood water

arches. She sees in the dark, the morphine drip

the song birds whose songs are stolen for research, migratory birds who are funneled and
disoriented disoriented, where is their gyroscope

Arthur Cleveland, RNA, employed at County General for six years. Employment terminated on xxxxxxxxx, incident involving a patient, xxxxxxxxxxx, released without discharge. Patient terminally ill, on morphine drip, hospice assignation, patient released from locked ward by Mr. Cleveland on xxxxxxxx. He informed staff that patient was "uncomfortable and unnecessarily restrained, sedated." Patient in advanced stage of bone disease, unknown origin. Mr. Cleveland claimed patient was a mystic, induced his cooperation. Termination enacted, psychiatric evaluation recommended.

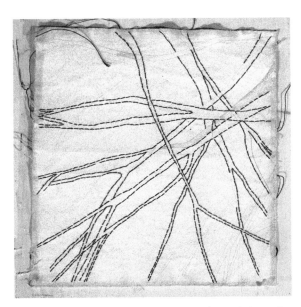

Fig. 2.5. *Branches*, 2013. Stitching, acrylic on hospital sheet, 12 in. x 12 in.

Intravenous.

Terra is an addict.

empty the glassine package rounded tablespoon capful of water over white-brown powder, lighter under spoon, bubbles, pull the cigarette filter drop it into spoon basin, fill hypodermic, cotton shot, rose blood bloom, liquid in cylinder plunges bubble pushing into brain vertiginous spreading weightlessness, the stomach-fall

she lets him fuck her and he gives her dope. so what. it's hot, fucking mosquitoes let them eat her, let them get her engine-sludge blood in their suckers. nodding on the couch. rehab did nothing, they took her kid. his dad has him now, too bad. tomorrow she'll get a job, tomorrow everything changes, tomorrow.

she thinks she's pregnant, that sucks. window's open. tomorrow get a pregnancy test. and go to food pantry. the window, there is a woman on her porch. how the hell—

Up on the hospital roof, shaking the morphine off

Tristia's arms are lead sticks covered with bone spurs, *dying*, she thinks. Last she knew there was one arm mostly gone. Weight loss

she feels fine. Hungry. *My body in revolt*, she thinks.

These look like wings, not tumors. Bone disease

She runs the roof. Like an infant tied to a kite.

Hands intact. Wearing a ragged snap gown, she rears her wings and dives.

Like painting, the next stroke

there like a net, a brace.

Every feather moves. She is tired, lands too quick,

bloody knees. Laughs, *where do I go now?*

She knows where it lies by air.[6]

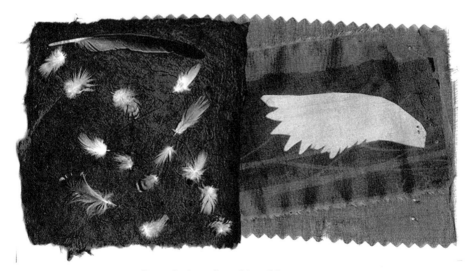

Fig. 2.6. *Weather Vane*, 2008. Paper, feather collage, 3 in. x 8 in.

6. This account is contrary to evidence that it was quite difficult for Tristia to fly at first. She was awkwardly heavy for a bird, though gaunt for a woman. Her muscles had experienced some atrophy during her imprisonment at the hospital, and the wings formed with relative rapidity. Terra Fuller kept extensive notes on the mechanics of Tristia's wings.

III

Chorea Terra/Terraemotus

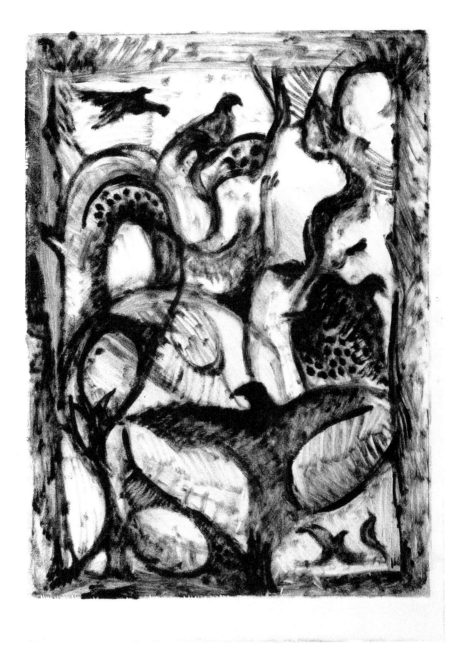

Fig. 3.1. *Bird Motif*, 2011. Monotype, 15 in. x 11 in.

Tristia, tired out by her migration, was sitting by a well. It was midday. A Samaritan woman came to draw water, and Tristia said to her, "Give me a drink." The woman said to her, "How is it that a bird speaks to a woman of Samaria?" Tristia answered, "If you knew who I am, I would have given you living water." The woman said to her, "You have no bucket. Where do you get that living water?" Tristia said to her, "Everyone who drinks of this water will be thirsty again, but those who drink of the water that I will give them, will never be thirsty. The water that I will give will become in them a spring of water flying up to eternal life." The woman said to her, "I see that you are a prophet. Our ancestors worshiped on this mountain, but you contradict the mode in which people must worship." Tristia said to her, "Woman, believe me, the hour is coming when you will worship no man, on this mountain nor in water. You worship what you do not know; we worship what we know, for salvation is from the sky. But the hour is coming and is now here, when the true worshipers will worship in truth.

—Letter of Severine to the apostates, from *Miraculum/Monstrum*. Appropriated from John 4:6–23

Australian folk song (round): Kookaburra sits in the old gum tree eating all the gumdrops she can see! Dance, kookaburra, dance, kookaburra,

leave some there for me.

How long, this wandering? Complete night,

a sealed metal box.

She can't see her own back! Pecks at her breast,

new down fine hairs form feathers.

A scar under there itches. Earlier she stole meat.

As she is seen by others, she is monstrous.

Feathers: the primaries a deep black

gloss, suck light away.

Secondaries reddish, dried blood

morphine wearing off.

She finds she can jump into a tree. This joy!

The flying leaves her weak. Her hunger fastens its need in her bones.

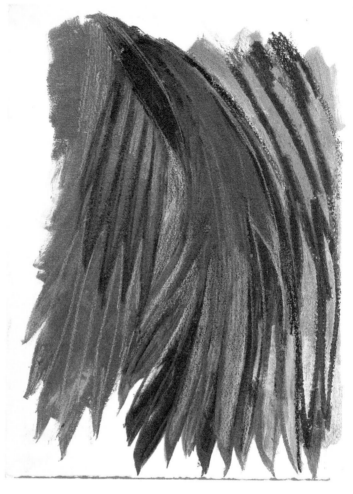

Fig. 3.2. *Red Feather*, 2012. Conté crayons on monotype, 15 in. x 11 in.

Hollow. Tree. Bones. Pain a red feather.

She must find. A woman is oil-laden, calling her, unctuous bleating.

Jump-flies to porch ledge. Terra shrieks. Tristia falls in.

In your memory, scarlet feathers of a beloved macaw begin a glow arising from the exact color of connection.[7]

Terra coming off her high, pain in her stomach,
the miracle: molecular and gargantuan. The miracle.

Here events defy category. Terra is chemically festered, belligerent—
disbelieves her sight, the walls buckle in, this woman

frayed hospital gown, torn

nipples visible but beast-haired—feathered, like a Halloween freak show,
blood on her mouth, skin scabbled like a crackhead.

Mortification dulls disbelief.

The beauty of her ivory underfeather cloaked with black, slick like tar. Terra
tries to hit the bird thing, throws a plate, her boot—pulls a lamp from the
socket and smashes—points the jagged end at the howling figure crouching.
Makes her weep. Terra sits on the floor, cradling glass. Closes her eyes, the
adrenaline disrupting her high. *What the fuck* . . . Listens while it speaks,
transfixed, can't move.

Tristia, she repeats the mouthed word the woman bird forms.

7. *Concordance*, Kiki Smith and Mei-Mei Berssenbrugge.

The wings hurt, where they tear the skin. They keep coming, bone hatchings. I escaped—

She helps her to lie down.

Bandages the cut she inflicted on Tristia with a washrag. Thinks of getting dope with wings, they could cop and fly off. *They could . . .* The way the bird knows what she's thinking and shakes her head, looks her in the eye—it freaks her.

Two orphans, each imprisoned

by their body.

Fear, revulsion give way to seal-fat mother giving shelter. Terra holds the feathered body.

Wet with each other

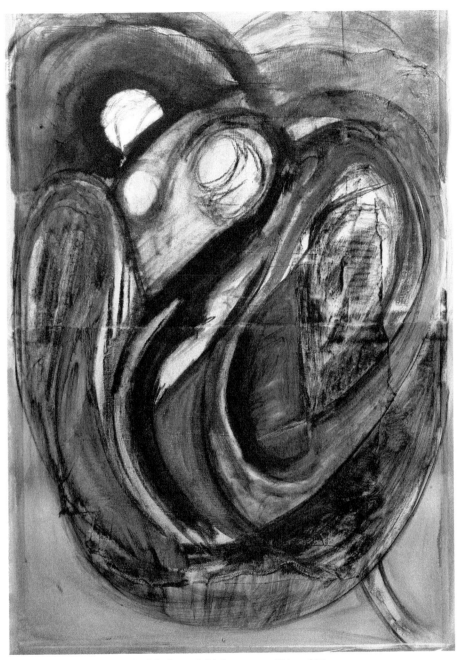

Fig. 3.3 *Heart of the Bird*, 2013. Oil, charcoal, fabric on paper, 36 in. x 29 in.

tears over the scabbed skin,
feather socket.
They whisper. Tristia tears Terra's skin
a little puncture for the drug in her blood.
All three in withdrawal.

I dig a grave for your needles, give me. Save the little body in your womb, your
implements of gouge and pick, do not thwart but listen. Bite down on feather stalk wait
the calling of demon out, out, there is not yet drug in bone, shed this weight,

addiction a smoke ribbon curls up and hangs.

The boy, he must be born, he is a prophet a king there is a crow masked eating from
raccoon body told me see him being born

see him![8]

Terra seeing with one middle eye, glazed, frightened, the birth of her child,
still months away. *How*

?

8. As an adult, Terra's son Trevor Fuller served an important function in diplomacy and mediation
tactics, and was instrumental in negotiating the Oxygen Treaty. It is unclear how Tristia could have
known this, but Terra wrote extensive notes on the prophecies Tristia revealed from her dreams, and
some we know have come to pass. Several of Terra's notebooks left behind in Melun were distorted in
the text of *Miraculum/Monstrum*, but some have been preserved or donated to the Museum of Latter
Hybrids by Terra Fuller herself.

(Curator) I am often asked how long it took for the wing growth transition to reach completion. How long did she lie drugged in the hospital? This would seem to be a simple matter of record, except many of the records were destroyed. We don't know why. We do know her cottage was emptied out and her things forwarded to her Aunt, Percy Vogel. Her relative was then informed that Tristia had volunteered for a long-term research project, which her aunt disbelieved; later she was told Tristia had fallen from the roof of the hospital. From a complete inquiry into all existing records, my estimation is that it took six months for her wings to grow in and become usable. As soon as she realized she had wings, she escaped. Though they attempted to find her through a previously implanted tracking device, this was apparently destroyed or surgically removed.[9]

9. During the six months that follow Tristia's escape from the hospital, she and Terra remain in motion after an attempt at recapture; while retrieving painting materials from Tristia's cottage they are almost apprehended by what appear to be hospital personnel. They soon realize Tristia has some kind of tracking device under her skin. They use various means (magnets and metallic tapes) to confuse or scramble the signal. This works to some degree and allows Tristia to become stronger physically. There is evidence that before Terra's decline into petty drug-related crime and addiction, she had schooled as a physical therapist. Terra's brief training helps her advise Tristia on muscle development to facilitate flight.

Feathers spring from her arms: changed into a bird, the rock dove, with its red legs and purple throat, she is called Ciris, 'Cutter,' and acquired that name from her cutting of the lock of hair.[10]

In the wing, a dance: sister love. Muscular gravity folding their weight.

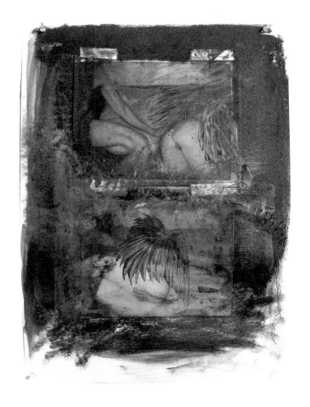

Fig. 3.4. *Birdshot*, 2013. Oil and wax on paper and wood, 35 in. x 25 in.

10. Ovid, *Metamorphoses.* (A.S. Kline version) Book VIII: 81–151

IV

PROSECTUM/PUELLA

Mother, lift us into the feather. Mother, wash us in dust. Mother, nest us in cries. Mother, lift your face to our deep cuts, in humility we serve you, in humility we fold, in humility we burn with you.

—Prayer poem "Holy Day," from *Miraculum/Monstrum*, verse 10.

Under the highway bridge, dark-knitted shapes
rest from selling. They lean against the cement,
light their glass pipes in rapt attention.
No one comes here, the whores' green room.
The cops sweep once a night, they scatter—
come right back, like a drill.

The trucks above shake the pilings. Tristia comes to buy,
to anesthetize her searing subcutaneous feather fault lines,
alights again clouding dust under the bridge in the dark.
Fluffs the road powder off rectrices, sneezes.
Tonight only three run. The time before the girls melted into short streaks,
sheeting rain run cold. Except Karena,

too badass to fear monsters.

Tristia in nervous motion, head jerks
to trailing edge of wing after attempts at recapture.
Gaunt, covered with fine definitive down, contour feathers
lay flat and gray on her chest and belly.
The fur swells on her breasts, nipples darkened, flinty.
Her calves in atrophy.
She hunkers into a squat.
The *plumula* on her back blanket the network of scars
where each primary feather
tore through her skin. There is bat-like bone,
fingers growing alula into the wing-bend.
Sharp unwieldy aftershaft, semi-plumes.

Under skin riven with feather picks, the glowing red pill sends out real-time
signal to data logging medics. The mechanized body, a traitor of flesh;

machine propagandizes animal.

Tristia speaks, garbled but lucid. The women listen in terror,
staccato heart eyes the bleached optic nerve,
improbable body snares in neurons of comprehension. They want to touch her.
Rest their hands on her feathers—not like feathers
they've seen or touched before. She smells
metallic, slurs her speech.

A car drives up, a car the girls don't know.
They swarm
over. Tristia vanishes into bracken
trash on the slope of embankment. Medics again.

The parasitic device inside her body
bleating her coordinates.
Narrowing down the food ladder she loses spring.

In her neck a pulse beats
time to a mysterious eye blink within her chest.
A throat blinking red, ash tip pustule.

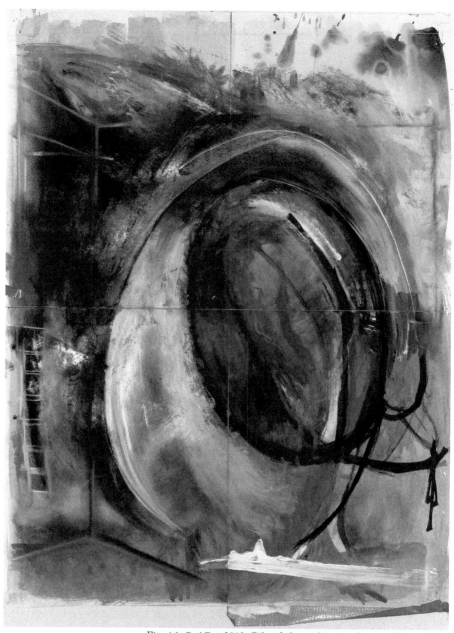

Fig. 4.1. *Red Eye*, 2013. Oil and charcoal on taped paper, 36 in. x 25 in.

Terra can hear it, ear pressed to Tristia's chest,
deep embedded machine sunk in tissue
a newborn electro-dragon teething
on gelatinous sprockets.
They razor the skin open.

A gash wound red-black, salty slit
under the clip light 100-watt blazing morbid rolls of red.

No bigger than a thimble, they crush it with a rock,
exoskeleton splitting with a party favor pop.
When does the paranoid door hang open?
What sneaks in?

Terra takes Tristia back to her cottage to retrieve
several paintings. Terra doesn't use now, her *nausea gravidarum* has passed—
the fetus grows there. *Will you paint again?* Terra asks.
Tristia thinks she must. Though her body is changed, her mind
looks through the lens of hand tracing tonal pattern over

a sensual line. A man's face on a page, the lower half erased,
maps an obscured dream.

She flies to the roof, dives
to the top of the tree,
glides
then back down, swimmy.
Wants to carry Terra on her back, just to the top of the garage. *No way*,
Terra laughs—she watches though. One more plunge, leap, shiver, run, frowl,
this joy![11] Fluff pants as she winds down. Later she'll need meds.

Tristia's pain, white needles
stitch in her bones, singe fire rip and bind. The violent flesh tip heals in quill,
nail heads back in, barb-wise,

<div align="right">

welt her sores. She dreams in a restless opiate fume
women who will come
for talons. She dreams also a half-face man.[12]

</div>

11. Journal notes from this time document the ecstasy of flight, the physical exhilaration of "air swim unbridled by gravity." Her writings appear to have been dictated and written by a steadier hand, perhaps Terra's. They remark with frequency a thought connection with common birds; she notes: "though their continuous presence blurs into the hum of background scenery, are constantly at play, in love and at war. They are hyper aware of humankind and their quest to destroy their habitat in the name of control and appetite." The songbirds had already begun to die off in large numbers along the coasts of North America at the time of Tristia's liberation, though the government and scientific communities had not yet acknowledged the cause. Research was made to say what was plausible, digestible.

12. Tristia needed approximately 14–16 hours of sleep during a typical day; she "sees" events in her dreams that were actually happening or were going to happen (as evidenced in the unfolding of "dream story" from her notes), and often she saw people connected to these events.

Her spinal cracking. Wind fingering her filoplumes.
Nerve tooth bites to touch.
Her genitals opening and vulva growing longer, *mons pubis*
creeping up toward belly fur, the down growing thick there.
She masturbates standing up, wings folded forward, kneading
into the flat opening with awkward feathers fanning.

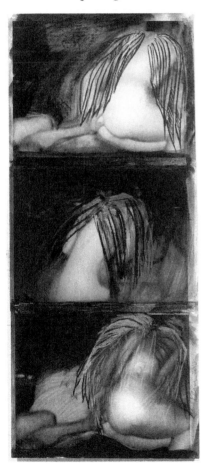

Fig. 4.2. *3 Birds*, 2013. Oil on printed photos, 32 in. x 14 in.

Where word reaches,
masses come to witness the bird-woman.
First the bridge, revival-like
then meetings revolve, graffiti-house squatters
vacant lots, dirt cellars writhing the abscess-armed *desperata*,
internet code forwards the flock.
The nascent legendary attracts
another kind of follower.[13]

The *Raptus* began writing of a bird-woman messiah in their scriptural text
Miraculum/Monstrum during the latter years of the twentieth century.[14] There
is great rejoicing at the news of Tristia. They send Kure to bring her home.

13. Dr. Kure (KOO-RAY), a Parisian of Japanese birth, among the higher-ranking members of the
Raptus Sect. The scientific community within the cult maintained a medical facility outside of Paris,
France (near Melun) specializing in ART (Assisted Reproductive Technology), and biological anomalies,
ranging from the common twin to recipients of birth defects. A research wing included vivisection labs
and others for progressive veterinary medicine. Speculation and rumor that experiments incorporating
spliced human and animal DNA surfaced periodically from the facility's inception.
Kure always wore a surgical mask, which covered most of his face. History reveals a more than hygienic
reason for the special mask. The *Raptus* texts call him a *Karura*, a white lacquered apparition. In
Japanese mythology, *Karura* is a man with a bird head or mouth. Kure studied anthropology at Oxford,
in addition to his medical degrees from Kyoto.

14. There has been speculation that the *Raptus* sect, also called *Monstrum*, descended from the Rapanui
Birdman sect, of Rapa Nui (Easter Island); the French were colonizing during the eighteenth century
and were partly responsible for an ecological crisis due to deforestation, causing the sect there to die out.

Karena[15] from Tristia's dreams:
caramel-skinned hooker, weal of ropy scar tissue on her cheek,
half-moon of broken bottle.
Tristia, from the dream branch, sees Karena murder a john,
sees her pulpy lip
spilling blood and the lost tooth.
The man is Salvatore Chow.
A low bird crall
issues from the woman, only Tristia hears.

Karena wishes: the cops want her, questioning, sure. Protection. Lockdown.

The john got off beating the girls, everyone knew.

Occasionally he'd strangle one, leave her body in the river silt.

His runners gonna take off her head.

15. Karena became a valuable witness, letter writer, and translator. She was able to easily understand the language Tristia struggled to speak as her mouth began to take on the claw-like properties of a beak, in France.

Karena Paola, 32, released from Wayland Hospital after being
treated for minor injuries received during an alleged attack
to her person by members of an organized gang operating in the
Jefferson Park area of East Harlem. Witnesses claim a large bird
disrupted the attack, mortally wounding one of the men.

The rabble, the infected, the poor, the addicted, the contented, the cogs, chaotic underlay, they come to see this miraculous bird, to hear her. Where all belief has atrophied, a bloom erupting, blood-furled. *One of us.*

Scabbed and broken

miraculous the way a nature-borne improbability

stops the breath.

She tells them, they listen

rapt: their broken backs pave the roads. Young mothers bring babies, walk under freight bridges with crack dealers, nurses, pimps, parolees, surging,

all leveled by a strange kindred impossible beauty. *Money runs the bridge built on your bodies.* The numb disconnect settling in living rooms in the glow of plasma screen. Here is a waking cry, a bird crall. The nest is dying.[16] She empowers a talon, a cry to revolution. Use the machines to take from them. It's the only way.

(Curator) Terra's journal from this time expresses her bewilderment at the spectacle of Tristia's bridge talks crowding out the reality of their lives, but acknowledges Tristia's divinity as "unearthly" and was proud to be close to her. Karena and Terra developed a strong bond as Tristia's flanking officers, which strengthened as the metamorphosis began to erode Tristia's cognitive functions. The two of them used handouts of money and food to take care of their friend, tried to emphasize the dignity of her sight through the disintegration of her human traits; but the constant hiding and moving was exacerbating their discomfort in propinquity, and Tristia was unhinging.

Tristia hysteria-flapping to Kure's offer, her body wracked.

She doesn't want to be anyone's anything. But.

This is how it will go. The dream cave,

the white branches over her.

16. There were two strands: profound waste, accelerated by denial and greed; earnest scientific communities, lured by the primacy of discovery into ignoring the common need. These strands, electrified currents stitched up DNA-like, caused the fall. In the midst of climate tumult, the governments turned blind and the planet creaked on its axis. Nuclear physicists pushed an agenda to extend time itself: the legislation of the project pushed a magnetic pebble over the lip of unified field theory.

Everything is happening at once, she sees the filmy separation of linear time,
falsity. She is already caved;
Kure will deliver her. The middle game
obscured by plumes of white pain, edged in peripheral visions
corridors and pairs of sainted bodies, ripe for dissection.[17]

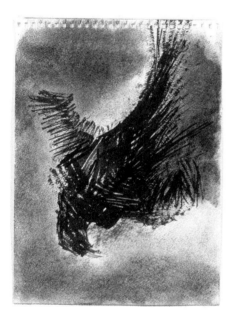 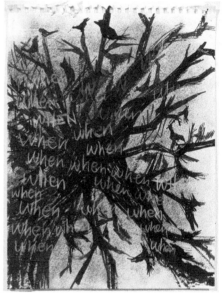

Fig. 4.3. *Falling Birds I and II*, 2014. Ink on paper, 14 in. x 11 in.

17. Harassment disguised as devotion courted Tristia, the number of followers made it difficult to move
and care for her without being captured. Dr. Kure offered a fabricated salvation, a way safely out. Karena
and Terra were faithful to her wishes, but with trepidation.

It's raining birds.
Veins of bird cloud fall along the eastern corridor,
pinion from their skyward hinge. The streets stink of bird hell,
smeared black jam on the roadway.

News trucks skid on rotting bird fruit and point their cameras,
feed the press stream serving after serving of fresh crow.
Rising smoke columns make a vaporous flock of fallen bird bodies.
They curl upward from rubbish pits, saturate cotton shirts, tree veins,
inhaled, tasted.

Running birds.
Disintegrated bird bodies rain into gutters, too many to count.
Bird drips fill where water collects. Burnt feather flesh sinters
to rugged leather. The cooling lumps in bird water.

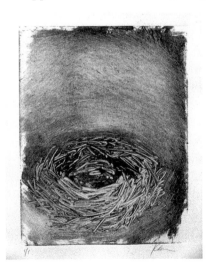

Fig. 4.4. *Empty*, 2011. Monotype, 18 in. x 12 in.

KINANGOP, Kenya–Simon Joakim Kiiru
remembers a time not long ago when
familiar birdsongs filled the air here
and life was correlated with bird
sightings. His lush, well-tended
homestead is in the highlands next to
the Aberdare National Park, one of the
premier birding destinations in the
world. When the hornbill arrived, Mr.
Kiiru recalled, the rains were near,
meaning that it was time to plant. When
a buzzard showed a man his chest, it
meant a visitor was imminent. When an
owl called at night, it foretold a
death.

 "There used to be myths because these
 are our giants," said Mr. Kiiru, 58.
 "But so many today are

 gone."[18]

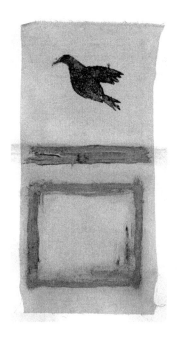

Fig. 4.5 *Memento*, 2013. Acrylic on bandage, 6 in. x 4 in.

18. Rosenthal, Elisabeth. "For Many Species, No Escape as Temperature Rises." Science Times. New York: *New York Times*. 22 Jan 2011. Print.

Kure must take all three, Tristia insisting.

It's difficult to understand her, though he speaks good English.

He must concentrate to listen.

There could be synapse disintegration, the strange word order.

Her friends will help her settle,

his private flash of surgical thought,

then they'll have to go.

Tristia, wary, alert,

blades his thinking.

I'll kill him if he hurts them.

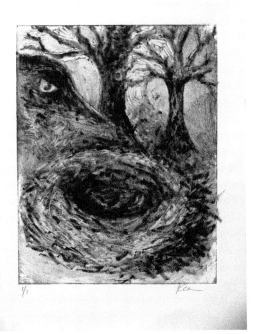

Fig. 4.6 *Mother Bird*, 2011. Monotype, 16 in. x 12 in.

V

Miscere In Vitro

We kept the girls housed and comfortable for as long as we were able to; this was for
Miracula Tristia's sake. But we were ultimately answerable to a higher authority.
—Michaela, former Raptus member, interview transcript

that's what they'll say about us generations hence (how living then hence without so many
animals then?) they fucked the world over in their sweet avaricious time frame that's what
they'll say, about us, those stupid fuckers, they let the animals die, they let the plants die,
they killed the air, they killed the water, they killed each other, they killed language
—Anne Waldman

All these are the beginning of sorrows.
—Christian Scripture, Matthew 24:8

Terra, Karena, Tristia situated at RM Inc., Melun.
Facility. Insinuated. Royalty.
Safely inside when the oxygen disaster escalates.

In seventeen miles of serpentine pipeline buried under
Geneva, subatomic particles collide at light speed in the Hadron
accelerator,

a five-hour drive from Melun.

Estrogen, progesterone.
Estrogen, progesterone. Levels:
two vials of Gonal-F. Two powders, Pergonal.
Two Gonal, one cc water.
Several vials of blood. Tristia walks the complex
perimeter. Adored.

The matrons attend. Morphine drip.
Antagon. Cetrotide. They discreetly insert
the needle tip, she is hungry
back ribbons, metal pain falling in sheets
throb in the long hollow of bone.

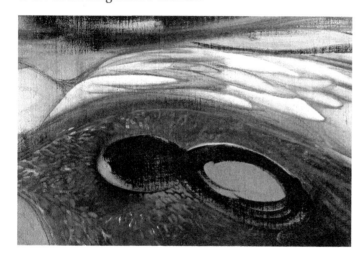

Fig. 5.1. *Open Swan* detail, 2014. Oil on canvas, 26 in. x 40 in.

Cetrotide, the two vials.
Estrogen, one Pergonal, two Gonal-F, Cetrotide.
Her woman's uterus, infundibulum and oviduct
clutching the heavy fruit.
She dreams bedsheets being pulled from her throat hole with a hook.
Neck trauma, face split.
Blood oranges, breakfast chocolate. Nothing but meat bits.
Morphine. Cracking her eyes, chipped milky white.
To sleep, to sleep. Sleep song.

The bridge in her mind, the girls.
Tristia gave them talons, a steely slit in their hands.
Here in the complex, Tristia sees the hospital matrons
tremble under masks. Afraid of what they worship,
the double edge of belief. She wants to be back there,
here she's irrational with bird mind, pecks her captors.

Pergonal, Cetrotide.
The babies mewling. Medea, no shame. Compulsory sacrifice.
Tristia's stick arm under the sheet.
The rat-toothed nurse pandering in fear,
afraid of the bird-woman. Vials of blood
progesterone.

Why sone tear mast catch, Tristia honks syntactic scramble. *lift ward hont red.*
She means *I want to go outside.*
The government has banned *outside*,
has dispensed oxygen.

A slight shift of cant, revolution,
the earth wobble, a stable micro black hole
slow-moving, webbed in gravity's paw.

The radiant blue finger of entropic dance
picks the central egg crack. Core fissure, pressed dense
earth matter creates a magnetic monopole.
2014 finally proves *time* is a force,
carrying gravity, unifying fields.
CERN has technology to extend (slow) time.

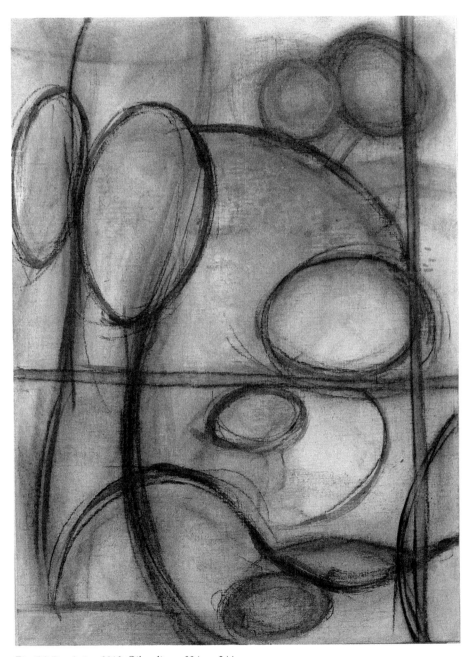

Fig. 5.2 *Revolution*, 2013. Oil on linen, 33 in. x 24 in.

The accelerator jet squelch injects slow poison:
the core shifts, earth crust quakes and splits.
Around the plates, livid molten rock births gaseous monsters:
sulfate aerosols displace oxygen. Chlorine monoxide ingests
the ozone. Red-tongued exponential death toll, fire sky.
What you won't believe when the birds begin falling.
Radiation slices accurate measure. Oxygen freefall.

She remembers Los Alamos, a family trip from her seventh summer,
sixty miles of coiled spring winding through the sand.
I can see the atoms! she shrieked.
That's gypsum, her father said. But she really could see.

Proton cocktails, metallic red swizzle.
Space weave, stitch hold
spiral unravel.

Kure in the dark red light, mounts her on the stainless table, little metal buckles
hold her in stirrups. The low chanting of watchers ebbs. The hush amplifies his
grunt. Afterwards the matrons anoint.
Operating theatre like a coliseum. The matrons roll her on her side to be sick in
a tin.

There's bleeding.
Tristia can only say *blood charge blunt frack.*
Spill. Ill mind, red thug stock. Wing-hont, lie bore.

The barbaric lip of the world spills.

Hintering-map-dream-story, the hinterland, the shore between sleep and waking, the interstice. She dreams the gleaming metal ship, pointing its bow toward magnetic north. This is not. True.

North. Undertaking the gravity/time protraction.

The finger bones long and ragged, her chest rasping.
Whose sperm in the eggs.
Witch's brew. She doesn't want to vessel these beings.
Dogging her, in explanatory tone. Tristia labors for hours, they extract six pearlescent grapefruit-sized eggs. Dr. Kure puts them into the sacred incubator.

She gears her fine-taloned will to break their eggshells.
They feed her mouse bits. Imprisoned, sky taken.
Dr. Kure, monster. *Karura*, bird beak.
Inserting metallic instruments, narcotic gumdrops
soothe her.

Runs the halls cralling: *Terr! Terr! Kren*, blood clotting on the thigh down.
What have they done with my family?
Calmer, she pays a diplomatic visit to the eggs with matrons in attendance.

the hinter map, the Matrons' Mind's eyes close and they dream standing up, of concentric pebble rings lulling away

They dream awake.
Tristia smashes the eggs with her feet
blood pulp, all dead. Gore pressure underfoot,
meat slime. Chips of shell, density.
Smears on the tile, red lights.

Matron guards spill saliva string, frozen in pale anger.
Emergency exit alarm, swooping in electric yell.
She left one alive enough to observe the entrails coiling hot.
Flies into sulfurous air as far as she can before falling.
Catastrophe will postpone their searching.

Lies on the ground filling lungs, continues south. From the air, dead
cattle reek, cars perpendicular on the motorway. Settles in the Forêt des
Palanges, to the east of a sign for Rodez.

A cave behind a waterfall.

Fault line miraculous without rupture.

The hinter map peopled with mind harpies and conjoined twins.

Scoring symbol text, blackened spit. How real a wing, caught in

mangled shell, soft shredded blanket, tree limb, nested in,

where there's nothing now.

Breathing,

then not even.

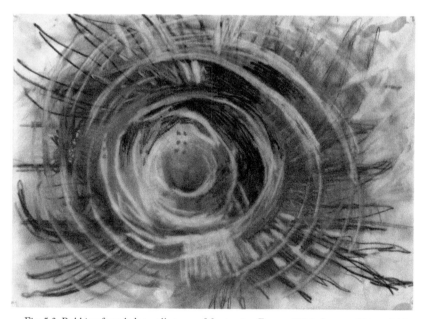

Fig. 5.3. Rubbing from ledge wall at cave, Montrozier, France, 2015. Approx. 18 in. x 24 in.

VI

EPILOGUE: HINTER MAP

crall. teeer. ummm-ummm

maw. raH! rah, rah, rah mawwwww. ummm-maw! ummm-maw.
teeeer, teeeer, teeeer. rahhhh. mm-rahhh. mm-rahhh.

teeerrah! teeeeerah. terrrram teeeeerum teeeerum.
cral, cral, cral, cral, cral.
mmm-cralk, craalk, mmmahcral, mahral, mahral, mahral
creee! creeee! creee! creel, creeeel, creeeel, crrrrrrm.

—Karena Paola, from her journal. Poem after *Tristia*.

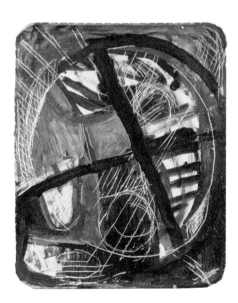

Fig. 6.1. *Reproduction,* cave wall, Montrozier,
France, 2015. 24 in. x 15 in.

Meeting Tristia (Endnote)

When I was an adolescent, and most children my age were either preoccupied with android companions or out exploring the vast network of tunnels constantly being created to support the post-surface life that our species now enjoys, I was in the library pod nearest my communal block poring over books about history. I enjoyed cultural histories in general, but specifically, I became transfixed with the pre–climate disaster era.

There I encountered stories of the bird-woman, Tristia, and learned the little-known fact that she had been an artist before the onset of her illness and struggled to make work up until her death. I was captivated, but also frustrated that this crucial part of her story is overshadowed by more sensationalistic lore.

Pre-disaster world history programming is distributed to post-elementary students in plentiful partitions, following the extensive coverage of climate disaster in the formative grades, but much of the detail is lost in attempts to load such a profusion of accordioned sections. This is an unfortunate flaw in our educational programming system. I was fortunate to come from a family of library keepers and archivists, so many hours and days and weeks of my young life were spent in the gated stacks perusing the stories from the past. Therefore, I was afforded more resources to search, regarding her case.

Tristia Vogel was the first documented case of Dysplastic Avian Mutation on record, and she has become a rather important icon for this affliction. The exact origin of DAM has eluded the International Medical-Veterinary Association (IM-VA), though it is presumed a byproduct of poly-layered genetic modification exacerbated by molecularly altered magnetic fields and massive shifts in atmospheric chemical properties. Many in the latter end of the twenty-first century have sought what little has been written about her,

or made the arduous above-ground trip to see the cave in Forêt des Palanges in Montrozier, where her remains were discovered some five years after her escape from RM Inc. Terra Fuller survived the oxygen fall, a feat in itself, with all the chaos that immediately followed; her tenacity in the search for her friend was at length rewarded. Terra collected and catalogued the artifacts from the cave, and we have her to thank for donating her collection to this museum.

It has been a tremendous privilege to compile the art objects, artifacts and documents for this exhibition. Tristia has been a significant figure in my own history, as I too am afflicted with a mid-level DAM, affecting my spinal column, reproductive and digestive organs. It has always been my intention to work further into the materials left in Tristia's wake, but to level my focus as art historian, rather than to further any exploitation and corruption her condition prompted, and continues to invite. It is a fascinating intersection that only humans affected by Dysplastic Avian Mutation are able to breathe the atmosphere without the mandated breathing apparatus. It is a gift then, from our genetic sister: to walk in the air, to see the sky and imagine birds, the joy of flight.

—Carla Kase, Curator
Museum of Latter Hybrids (Post–Climate Disaster Collection).

PLATES

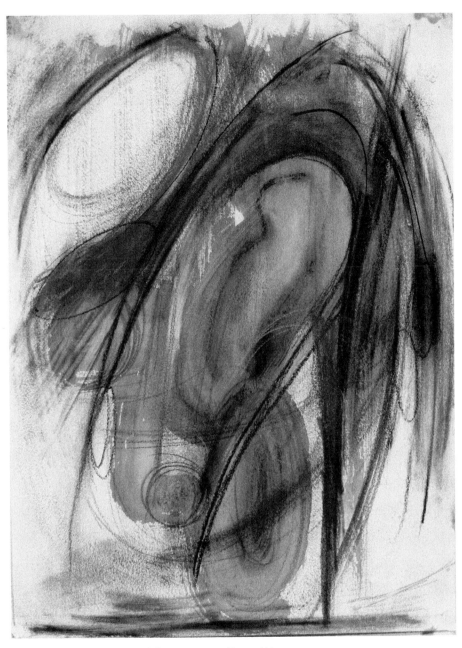

Plate 1. *Egg Birth*, 2014. Oil and Conté on paper, 15 in. x 11 in.

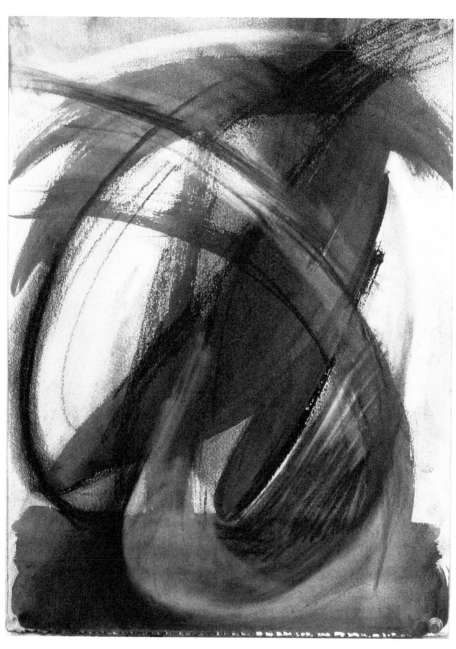

Plate 2. *Search Light*, 2014. Oil and Conté on paper, 15 in. x 11 in.

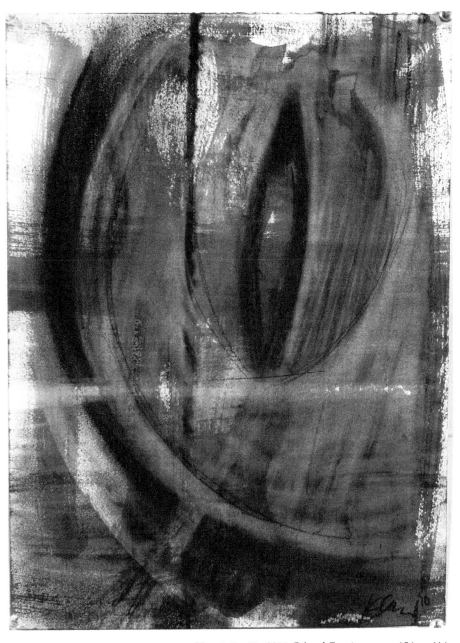

Plate 3. *Eye Slit*, 2014. Oil and Conté on paper, 15 in. x 11 in.

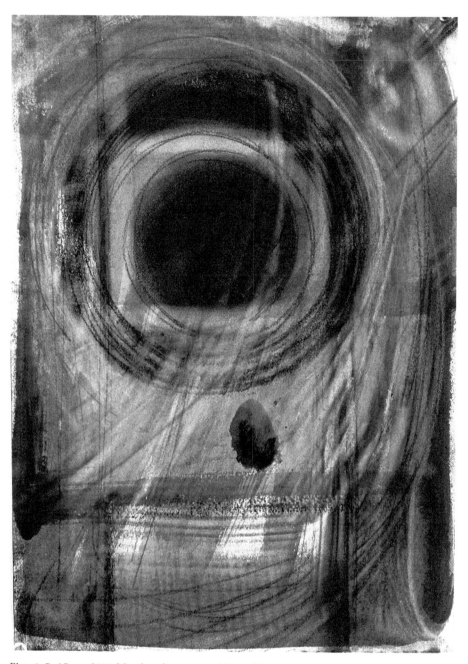

Plate 4. *Red Room*, 2014. Mixed media on paper, 15 in. x 11 in.

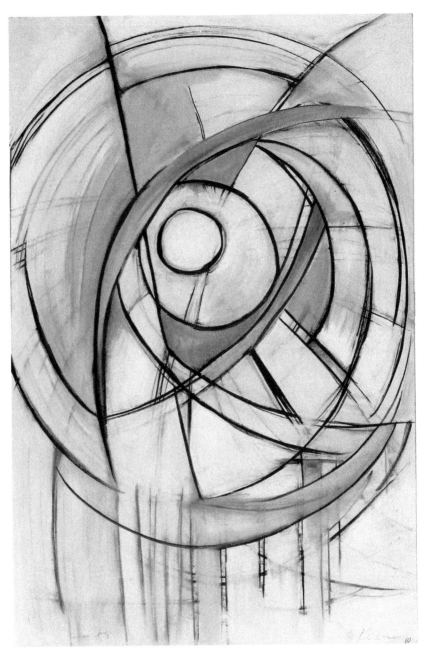

Plate 5. *Latter Eye*, 2014. Oil on canvas, 48 in. x 33 in.

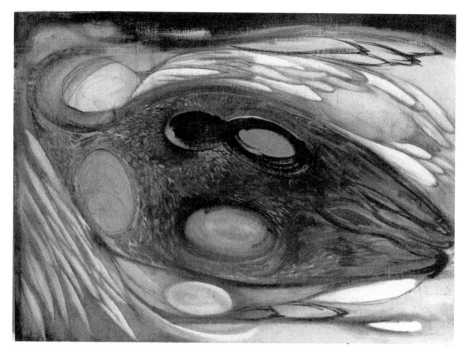

Plate 6. *Open Swan*, 2013. Oil on canvas, 26 in. x 40 in.

ILLUSTRATION CREDITS

Cover image: Kathline Carr
Listing is by figure number.

INTRODUCTION

1. Photograph: Terra Fuller, circa 2013.
 This photo was probably taken when they returned to the cottage.
 Museum of Latter Hybrids Archives.
2. Museum of Latter Hybrids Archives.

I. EXORNATIO

1. Sketchbooks provided by descendants of Percy Vogel.
2. *Landscape/Bird*, courtesy of private collector. This painting exhibits a more delicate hand than her typical later works.
3. *Ovoid*, courtesy of Tristia Vogel Studio. One can detect a compulsive fixation on egg shapes in work of this period.
4. Museum of Latter Hybrids Archive.
5. Museum of Latter Hybrids Archive. This simply executed watercolor was one of the last paintings before her hospitalization.
6. Courtesy of Percy Vogel estate. This piece predates her mutation; the apparent growth of a tail feather indicates Tristia's sense of future events. One can only speculate about the work's intention, since she left no written account of it.

II. Auguratio

1. Courtesy of Terra Fuller Estate. According to her earlier journals, Tristia often felt paranoid about people watching her. During and after her mutation, she did not retain this fear.

2. Courtesy of Brookside Hospital. Many of the pieces she made during her stay were executed on found materials, paints and thread given to her by hospital staff. Even after she became a risk-level patient, hospital staff continued to smuggle supplies to her.

3. Ibid. This drawing illustrates a kind of claustrophobia likely induced by Tristia's confinement.

4. Ibid. No explanation has been found to explain how Tristia obtained these photos out of her case file, or the medium with which she transferred them onto her sheets. Most likely these, too, were furnished by hospital staff.

5. Courtesy of the Estate of Arthur Cleveland. A gift to her patron. His aid in her escape resulted in his termination and subsequent persecution by Brookside.

6. Courtesy of Percy Vogel Estate.

III. Chorea Terra/Terraemotus

1. Courtesy of anonymous donor. This exhibition has induced several anonymous gifts of Tristia's work. Some of these pieces may be among those that went missing after her cottage was sealed. Painstaking measures have been taken to assure their authenticity.

2. Gift of Trevor Fuller. This piece was among work she made while Tristia and Terra were hiding from presumed hospital personnel. These pieces were put into storage by Kure upon their departure from the United States; they were released to Trevor Fuller after a lengthy court case.

3. Courtesy of Trevor Fuller Estate.

4. On loan from anonymous collector.

IV. Prosectum/Puella

1. Courtesy of Trevor Fuller Estate. There is evidence in this piece of a looser hand in Tristia's work of this period, most likely a result of physical changes in her hands and arms.
2. Museum of Latter Hybrids Archives.
3. Sketchbooks provided by descendants of Percy Vogel.
4. Courtesy of Percy Vogel Estate. The deterioration of the environment was very much on Tristia's mind at this time, as evidenced by clippings, books, and many drawings and prints.
5. Courtesy of Brookside Hospital.
6. Courtesy of Percy Vogel Estate. See 4.

V. Miscere In Vitro

1. On loan from Under City Arts and Culture Museum.
2. Ibid.
3. Gift of Terra Fuller to the Museum of Latter Hybrids.

VI. Epilogue: Hinter Map

1. Museum of Latter Hybrids, Archeological Department.
2. Gift of Terra Fuller to the Museum of Latter Hybrids. This piece is one of a series among Tristia's last paintings, completed at Melun shortly before her escape. *Egg Birth* shows a certain mastery over her media in spite of physical limitations, which had become quite marked in France. The pieces removed or reproduced from the Montrozier caves show a returning difficulty in handling her medium. It is known that Tristia's access to materials at the caves was extremely limited, and her resourcefulness is a testament to her consummate art-making.
3. Ibid. When this series is seen together, a kind of narrative of Tristia's incarceration begins to emerge.

4. Ibid. A return to paranoia, as Tristia is intentionally cut off from her companions at RM, Inc.

5. Ibid. Clearly Tristia is relating her ordeal through her work, with the sense of confinement and anger vivid in the color and slashing lines and scratches.

6. Ibid. *Latter Eye* is Tristia's last known painting, in the traditional sense, though she continued to make art in the caves until her death.

7. Courtesy of Karena Paola Estate. This painting was completed in an abandoned building where Karena and Tristia were frequently spotted. The painting was left in the custody of Paola's grandmother, Leesa Moreno.